DREAMSCAPES

AND HIDDEN FACES

DREAMSCAPES
AND HIDDEN FACES

The Collages of Joanne Freeman

CAPRA PRESS

SANTA BARBARA

Cover and book design by RAVE & Associates
Scanning and film by In-Color, Santa Barbara
Photography by Reid Yalom, San Francisco

LIBRARY OF CONGRESS CATALOGING-IN-PUBLICATION DATA

Freeman, Joanne, 1935-
Dreamscapes and hidden faces : the collages of Joanne Freeman.
p. cm.
ISBN 0-88496-371-3
1. Freeman, Joanne,—Themes, Motives. 2. Collage—United States.
I. Title
N6537.F782A4 1993
760—6620 93-11144
CIP

CAPRA PRESS
Post Office Box 2068, Santa Barbara, CA 93120

FeMale figuRes

LandScapes

Surprising Presences

To Verne

Acknowledgments

Family, friends and fellow artists all encouraged me to produce this book. So thank you Verne, Christina, Suzanne, Jon, Jeff, Nancy, Steve, Betty, Larry Verne, Nobie, and June. I also thank my mentor, Helene Barber at the Pacific Art League in Palo Alto, who like all great teachers knows how to let creativity flow within artistic boundaries.

Another accolade to my framer, Bill Doubleday of Mulberry Galleries in Aptos, California.

I also wish to thank my editor, Marilyn Yalom, for seeing the book's possibilities and making the necessary professional contacts to produce it.

introduction

Collage is an art form full of surprises and accessible to everyone. It's an art of layers and strata where unexpected images can well up from below. You can think of it simply as painting with paper, or any substance that sticks with glue that can be combined with acrylics, pen and ink, and watercolor. In its broadest definition, collage has its roots in folk art where seeds, pebbles, leaves and all kinds of found objects in nature were arranged on homemade frames. Democratic in scope and using everyday items as its substance, collage did not require years of special training. However, its direction was forever altered just before World War I by Picasso and Braque, who incorporated pasted objects on existing paintings, and eventually brought collage into the realm of a fine art. Many inspired collagists have emerged since then, with their work displayed in galleries and museums around the world. In my collages, shown here, I have worked almost entirely with paper, occasionally painting acrylic backgrounds.

The fact that collage, unlike many other disciplines, forgives mistakes can free the artist to experiment without fear of failure—glued down "errors" can be obscured by other layers. Often this freedom can lead to surprising discoveries that make your canvas more daring. Many of my works, using the trial-and-error method and a "just start" mentality, turned into unexpected discoveries, visual revelations.

Materials used in collage are simple everyday products. Your raw materials are paper products instead of paint. Variety is as diverse as its artists. Unusual paper forms can be printed bags from stores, sheet music, maps, old dress patterns, annual reports, family photographs, calendars, and glossy fashion magazines. More traditional papers found in art supply stores are—colored tissues, construction paper, ribbons, rice papers, lace papers and whatever the market offers this season.

Then there are "found" objects that you stumble upon. Accidentally, I left a tablet of multicolored construction paper in the rain overnight. In the morning I discovered interesting patterns of colors had bled through the pages. Family photographs can be reproduced on a duplicating machine with eerie effects. Also any object that lies reasonably flat—leaves, rubber bands, netting—can be artistically arranged and duplicated, often producing stunning materials for collage. I have even picked up intriguing scraps from the street, well marked with tires and heels, for their certain charm.

Once you have a variety of papers, other supplies are readily available. You need a canvas or canvas board, although you can "collage" or paste on watercolor paper. Glue is the lifeblood of collage—Matte Medium works best for me. To avoid unpleasant surprises, I keep a small canvas board as a tester to see the effect of the glue and water on specific papers—some may stain. After this, a pan for your glue, a cup for your water, a few cheap brushes and away you go. I don't suggest this is child's play. It's invaluable to enter a collage class with a good teacher, and I was fortunate to have found both. If a collage class is unavailable, most libraries carry an assortment of collage books. They offer a detailed history of the genre and describe various techniques and give lists of supplies.

When I began collage ten years ago I had never taken an art course in high school or college. I was a babe in the woods. As I began to gain confidence, learning both from my teacher and trial-and-error, I began to let the papers and colors themselves invite the content of the work. (It's like nurturing a child: the parents guide without inhibiting the child's natural bent). Sometimes a photograph inspired me, but more and more my subconscious went to work without interference. Many feminine figures appeared, some beguiling and alluring, others depressed and unhappy, a few threatening—but always surprises. Often this "letting go" led into visual and psychological realms not consciously chosen that appeared on their own.

On the following pages you will find reproductions of many of my collages, and stories on how each was developed. For some, there's an elusive quality beyond explanation. I don't know where they all came from.

—Joanne Freeman

SYMBOL OF JOY

In a vivid dream I was a high-born maiden living in a castle and raging against an unseen father who was forcing me into a political marriage. This collage evokes that dream; unhappiness exudes from the figure, yet she clutches a ceremonial bouquet as if her life depended upon it. Certainly the canopy of dark blood-red hovering over her is like a blanket of evil intent.

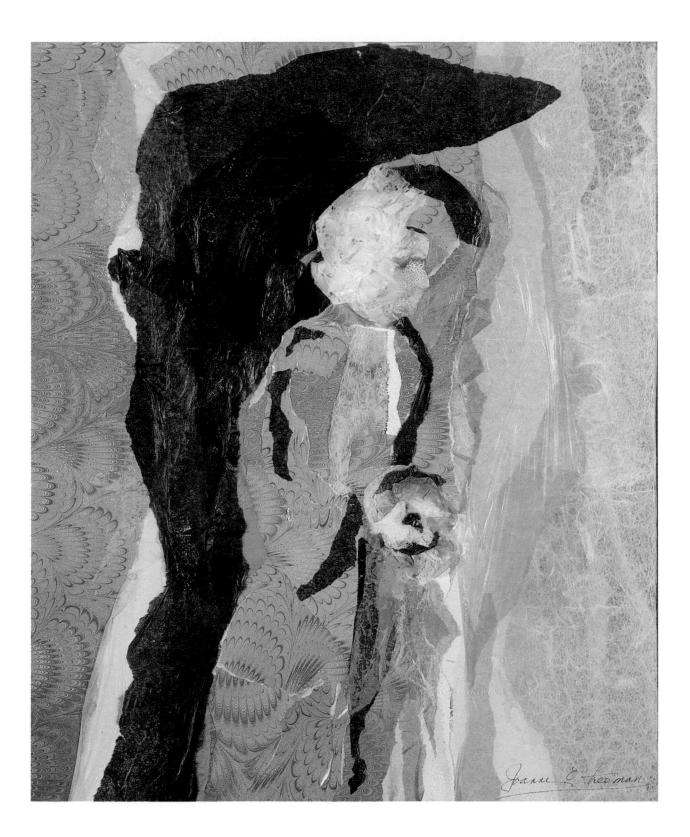

ZARIFA

A quick watercolor of a dancing figure was cut out, dressed and changed into a Mideastern belly dancer, with the corresponding peacock feather wrapping paper added for background. The dancer seems to glide in and out of the picture effortlessly. The blue on the the right behind her hair is an important resting place for the eye. The female is willing to please the male by dancing, but only on her terms. Look at her eyes without pupils and you will know.

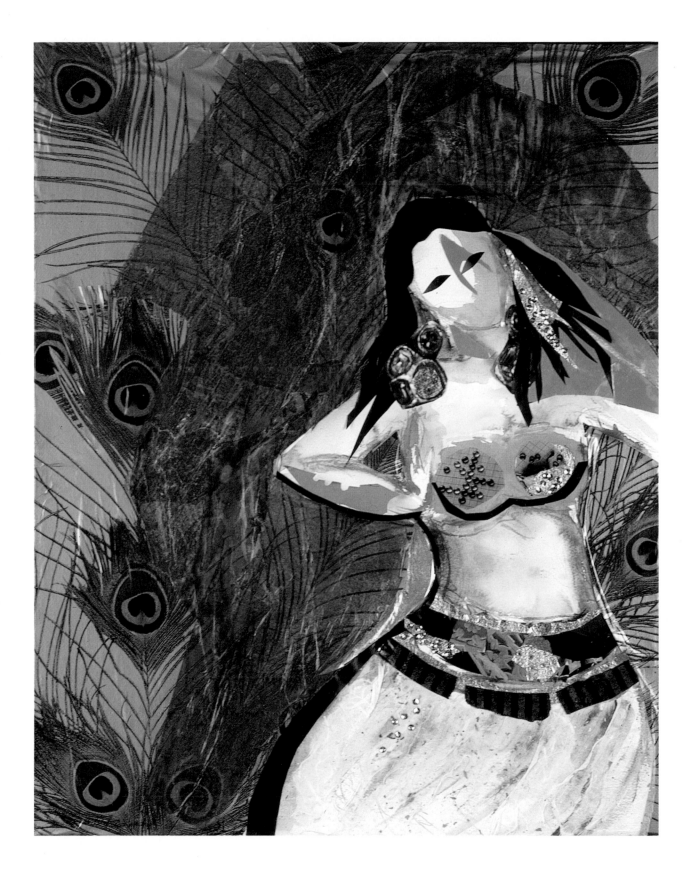

CHLOE

Chloe's sinuous neck appeared before she did—a curvy trail of flesh-colored tissue brought her into life. When I added silver hair, a twenties flapper appeared. Then I finished it with a flower at her throat, gray chiffon dress lying in folds at her bosom, and silver straps over her provocative shoulders. A woman of her time, Chloe peers at us from behind transparent pink-dotted paper.

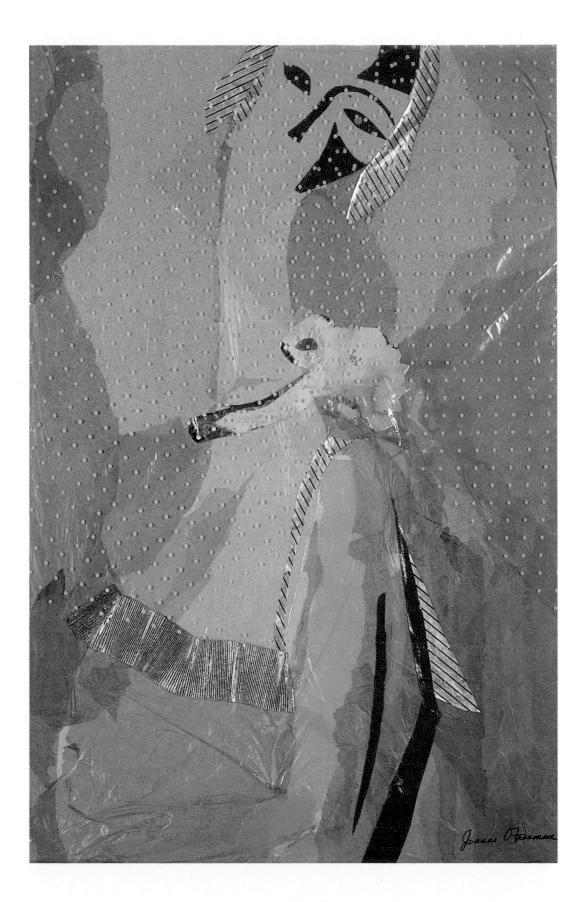

HIDDEN DANCER

A subservient Kabuki dancer serves her man in repose, displaying her fan and lowering her head. Her hair, reflecting the cowering cat in the lower right, is the only definite part of her. Is she a real person or only a part of her traditional kimono? I intended this picture to be a wedding present for my first child to marry, and the subject would be a bride walking over the brow of a flower-covered hillside. Too much planning and thought blocked the subject matter. When I turned the work on its end, the hillside became the Oriental kimono. From then on, the painting flowed.

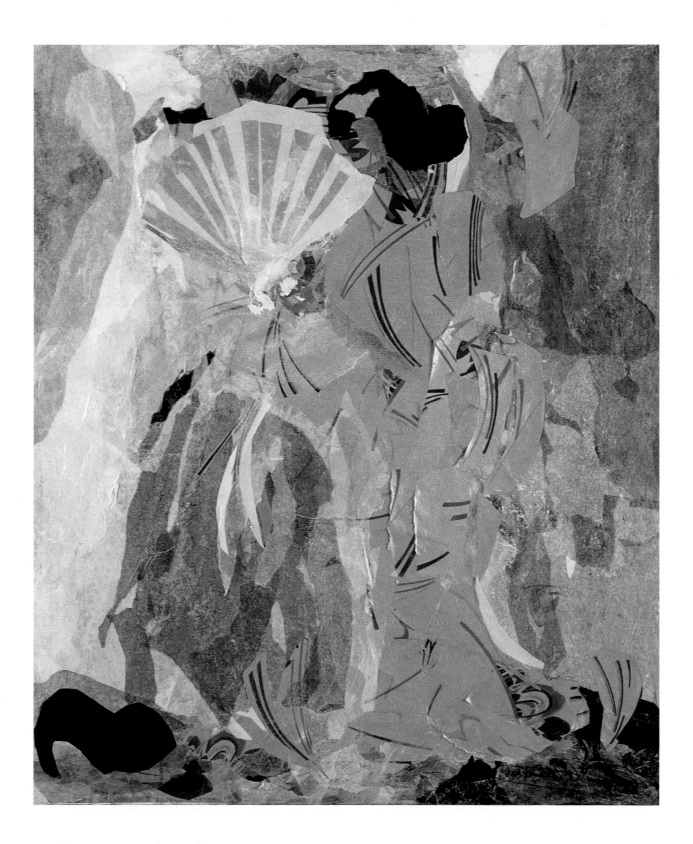

EMPTY ARMS

*T*his female figure with the stylized face began life as a man, seated as she is, but with more massive shoulders and a masculine slouch. Trying to bring in the shoulder line as I changed male to female, I used a gold marking pen to delineate the shrinking body structure as well as her arms and hands. The baby is sleeping soundly in its cradle, oblivious to its mother's empty arms.

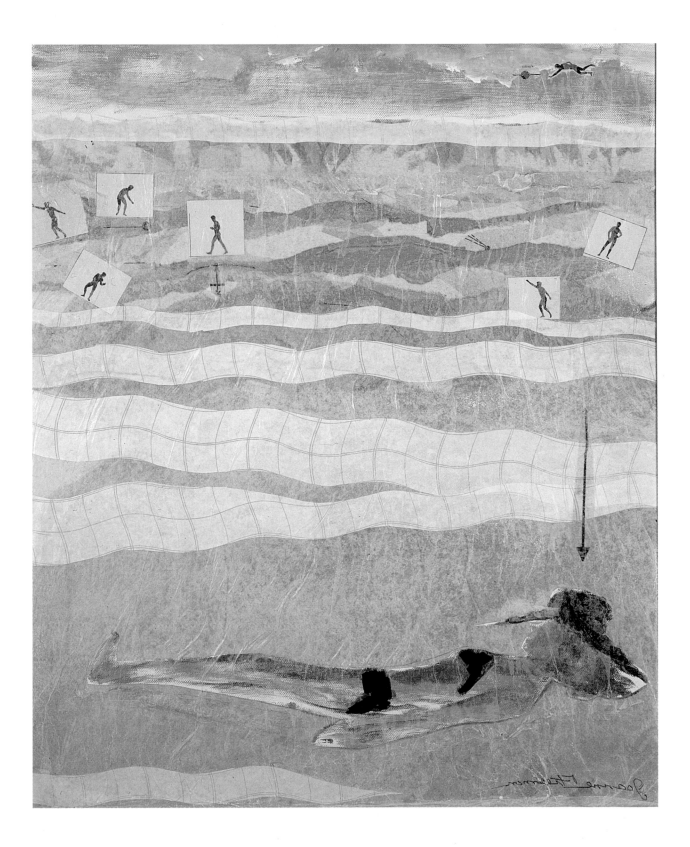

I DO NOT SEE YOU

Here are sketches from figure drawing class together with a silver background and cut outs from old watercolors. I covered the entire work with a gauzy lace paper which gave some of the female bodies a more natural color. My psychology-major daughter chose to interpret this collage for one of her class projects. She perceived hidden hostility and violence, as expressed in the headless bodies, the threatening dagger-like object on the left aimed at the missing head, and the full female figure on the right wearing a mask and holding up her hand to hide behind. I was first shocked by her reaction, as I had benevolence towards these female bodies, but in retrospect I became aware of the violent images.

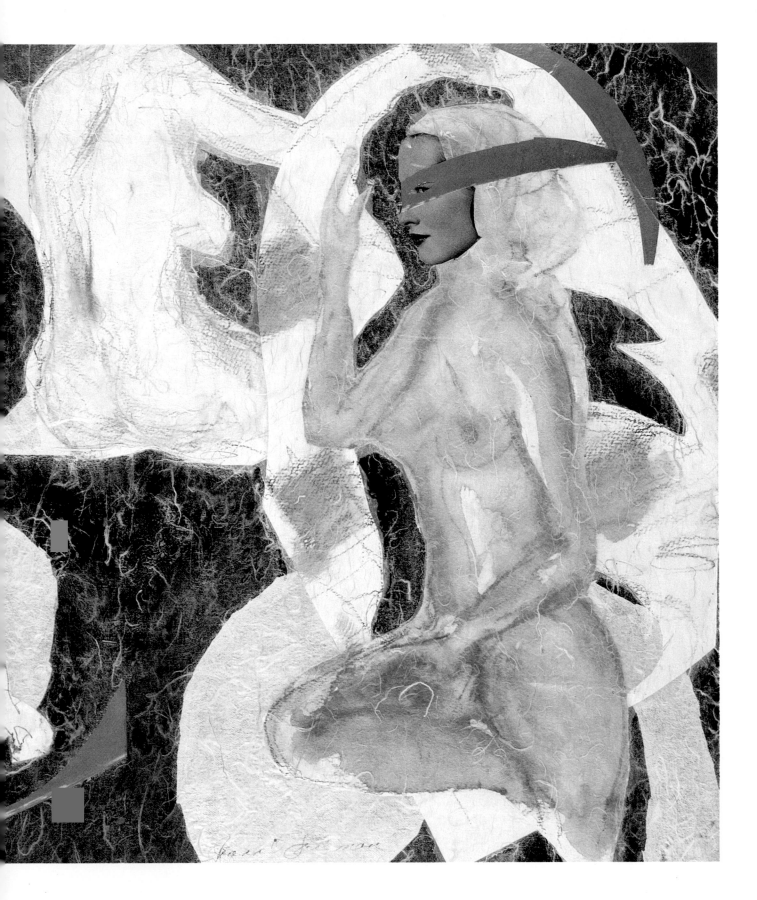

HARMONY WITH
THE WORLD

When I awaken in the morning, I often see this portrait of a woman day dreaming about her life. The burgundy curtain overlaid with transparent lace paper stretching in front of her opens out to bring her into harmony with the world. The starry paper represents infinity. The shadowy white figure emerged on her own—she was always female. All I had to do was define her jaw area, add her arm and hand, and she came into focus.

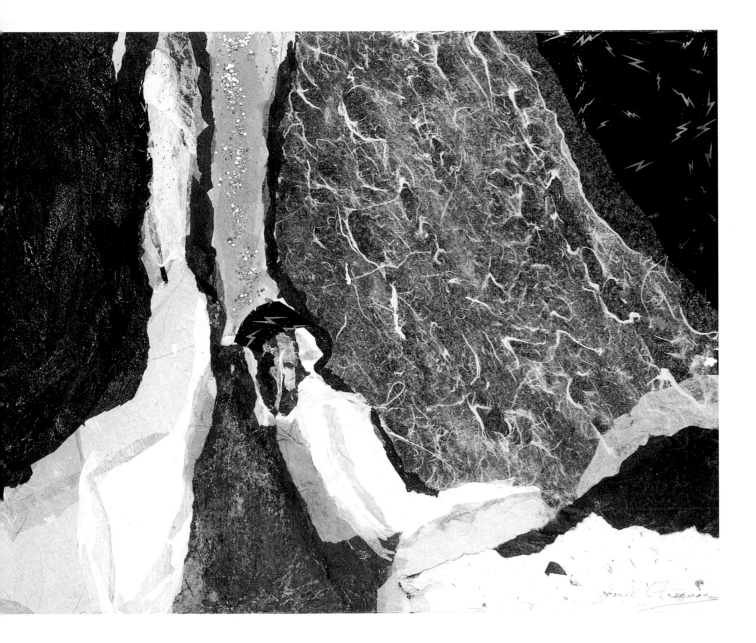

NIGHT GARDEN—GOOD

A quiet figure meditates in a night garden—a rock is her seat and the moon and trees are her companions. The serenity of the composition is slightly disturbed by snake-like undulations from below, but she remains confident in her good view of life.

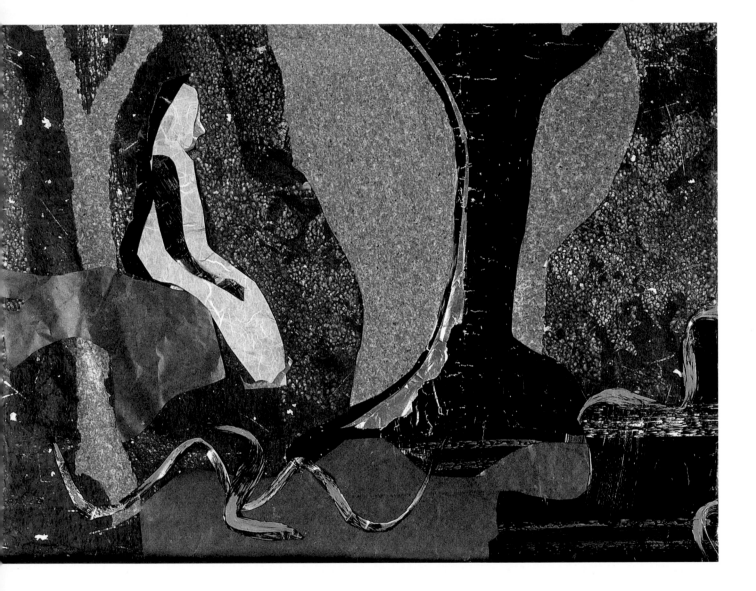

NIGHT GARDEN—EVIL

I was trying to overlay this collage with black lace paper, but it wasn't working. In frustration, I picked off part of the paper in the center and a beautiful melange of colors and papers emerged, reminding me that, yes, frustration can lead to experimentation, and then to a provocative expression. The two figures are leading mysterious lives of their own, and may be up to no good.

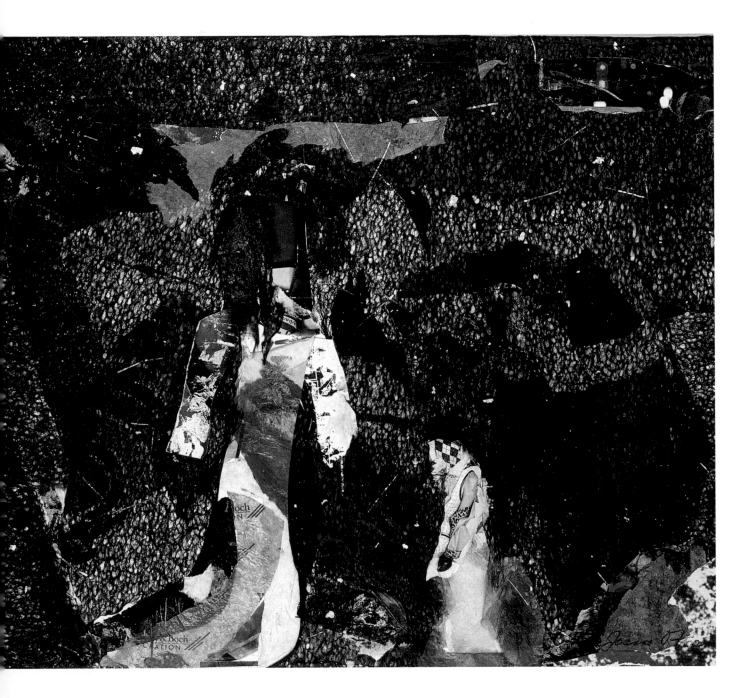

THE CAT KNOWS ALL

A floral wrapping paper in the center, blue and cerise lizard-like papers, and red designer papers as the edging form the background for two figures contemplating each other. Using both front and back of a friend's discarded watercolor, I tore shapes that produced the basis for the figures and the clothes, hats, and crowns. It seems that the accusatory tension springs from the female with the huge headdress, in opposition to the regal male on the left—the object of her frustration. The relaxed cat below knows all this.

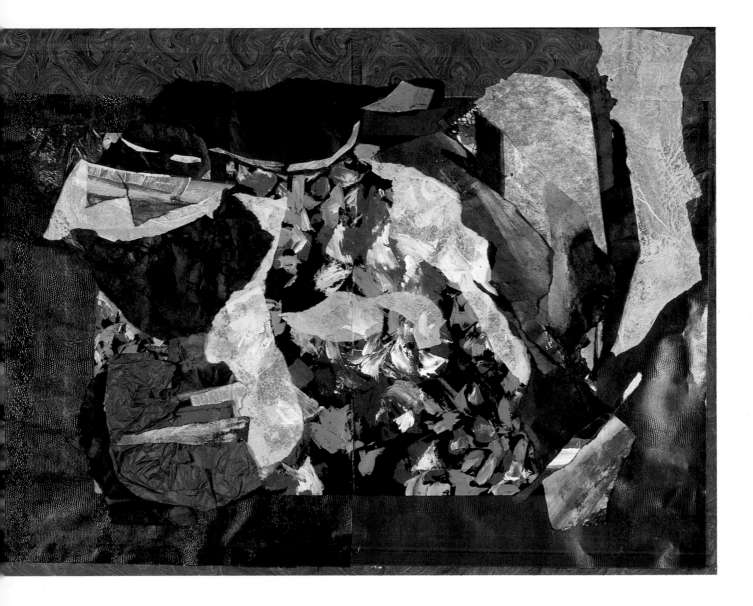

GOODBYE TO LOVE

A stiffening material used in tailoring created the retreating female. The male seated in the foreground was the result of a mirror image of a man sketched in a drawing class. The bat-like creature throwing roses appeared spontaneously and represents the end of love.

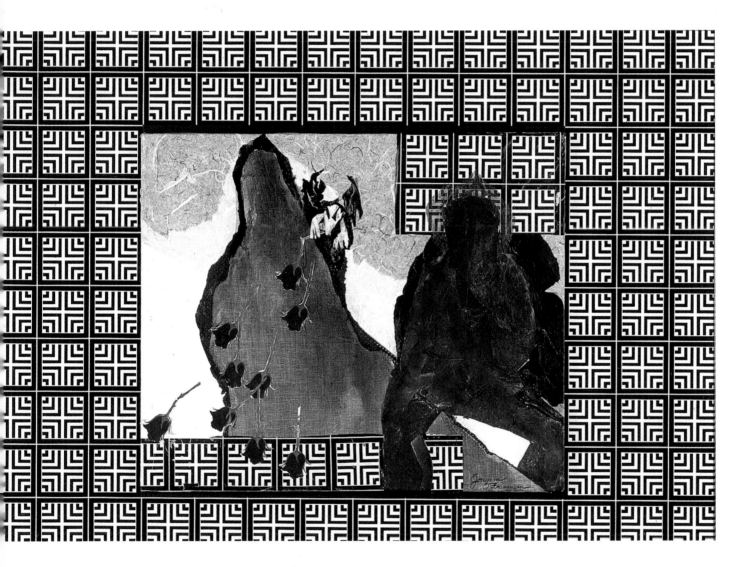

A TRIP TO BOUNTIFUL

Peaceful acceptance radiates from this waiting woman. Her feet curl behind, her hands relax in her lap. Life pursues her, drawn by her calmness. This was a difficult collage to organize, since the loosely sketched figure was small in comparison to the two by four foot canvas. I moved the figure all over trying for harmony. Finally, I positioned her above the middle, added the vertical ribbons, and the collage composed itself.

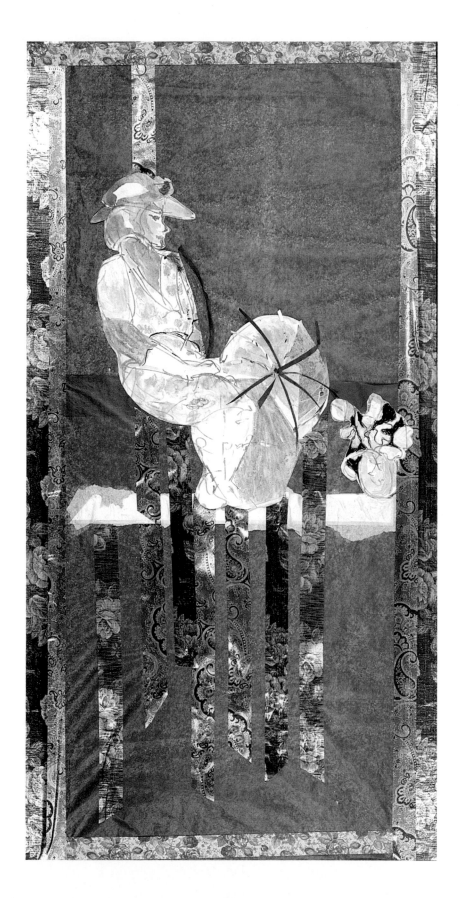

MOUNTAINS MEET THE SEA

The oldest island in the Hawaiian chain, Kauai, possesses one of the wildest and most spectacular coasts in the world—the Napali. Two-thousand-foot cliffs plunge into the foamy surf below, mountain goats and wild pigs thrive in its secluded atmosphere, and access is hazardous by trail or boat. I tried to capture the essence of this beauty, layering tissue extensively for the sea waves. It took many hours of work.

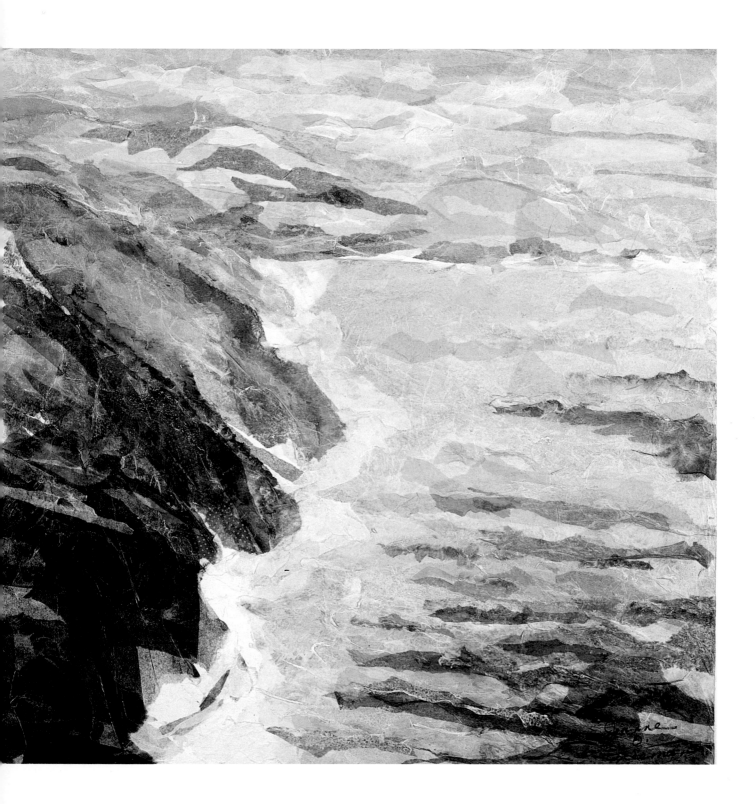

HAWAIIAN LEAVES

A photograph taken by the roadside on Kauai inspired this leaf collage. Using Fadeless Art Paper, I cut out patterns in many colors and fanned them onto the acrylic background. The final impression is of undulating movement, emphasized by the sinuous vein patterns in the leaves. The colors do not appear in nature, and the repetition of the unexpected white, blue and pink moves the eye through the collage. Since this is larger than usual, I used regular dressmaker pins with wider heads to move pieces around the canvas and to complete the composition before gluing. In this intricate intertwining of paper leaves, I often had built five layers before starting to glue. I had to turn back each layer carefully while gluing the one below, and this demanded particular patience and care.

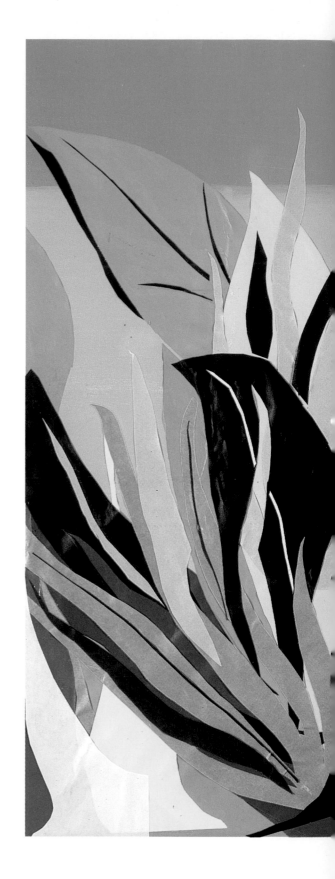

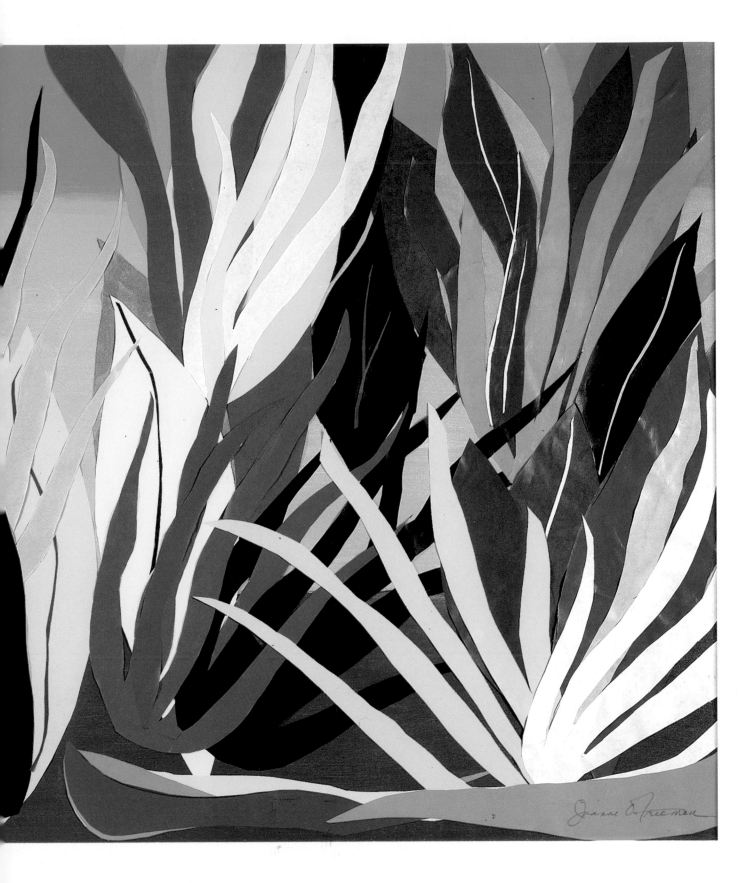

UNDER THE SEA

A discarded marine calendar inspired this collage. A diver emerges from a cavern on the sea floor, while airborne dolphins break the water's surface. Above, a coral reef teems with tropical fish and manta rays. Clumps of coral are caught in nets of lace paper. Bright pools of water dissolve in the distance to pink hills, blue-starred mountains, ballooning clouds and finally, blue sky above.

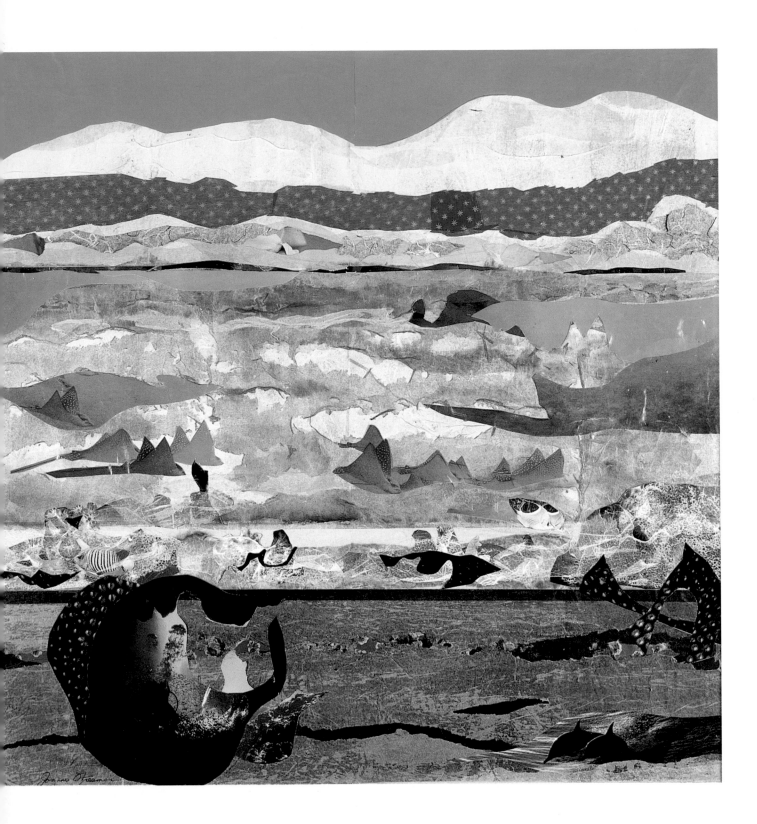

CASTLE ON A HILL

*S*olid rock, with deposits of shale, quartz and gold, form the hillside barren of plant life. It heads up to a castle anchored on a jagged ridge above. The occupants of this medieval fortress seem well protected from any invaders who would dare the hazardous cliffs.

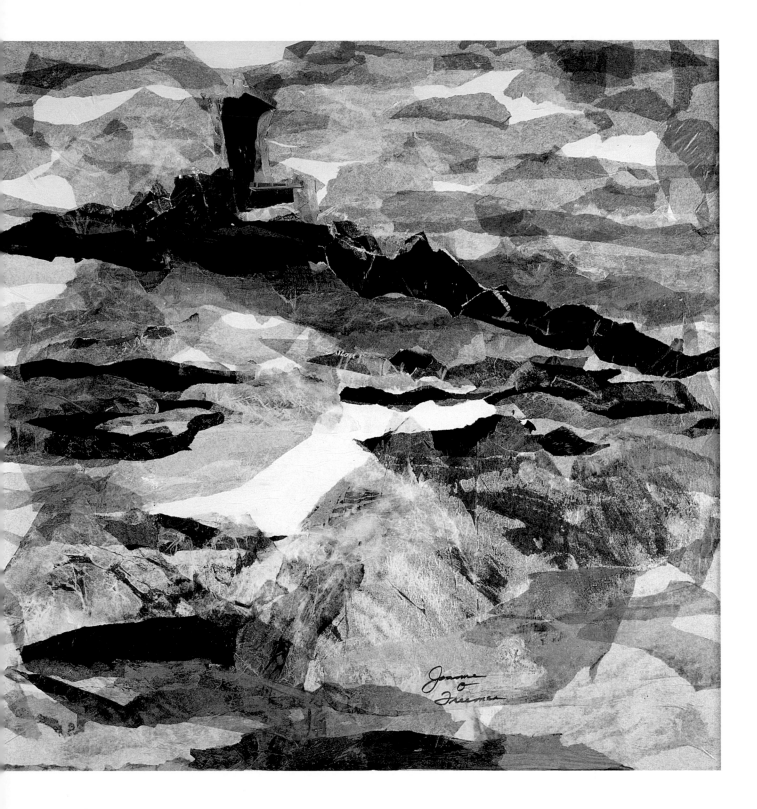

FLOWERING IN FORM

This representation of Hawaiian flowering tree branches is basically acrylic paint overlaid with yellow tissue. Brownish, thready rice paper creates shadows for the dull dark branches, and a mixture of exotic papers and cut outs from magazines form the flowers and leaves. Flowering branches are a common art subject, so the interest here, I believe, is the use of paper with a stylized Oriental feeling.

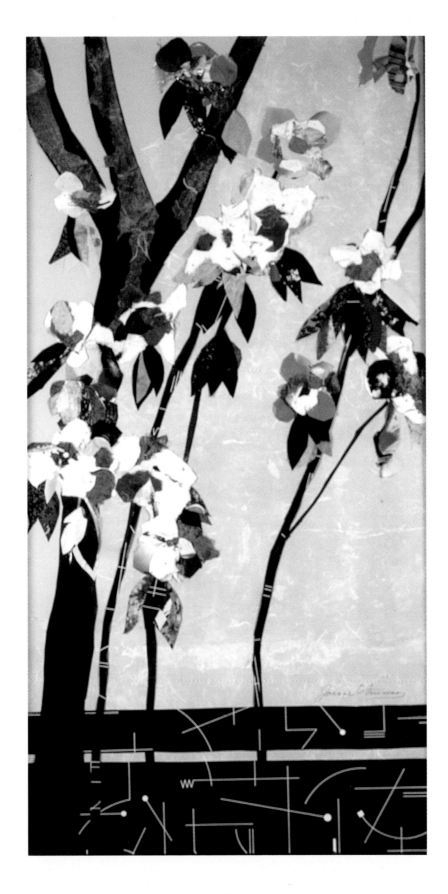

FOOD CHAIN IN ACTION

This design was suggested from pieces of paper leftover from "Hawaiian Leaves." I used the large scallops of magenta, blue, and black as an edging and changed the left-over leaves into a large hungry fish. A school of smaller fry dart in the seaweed to avoid being eaten.

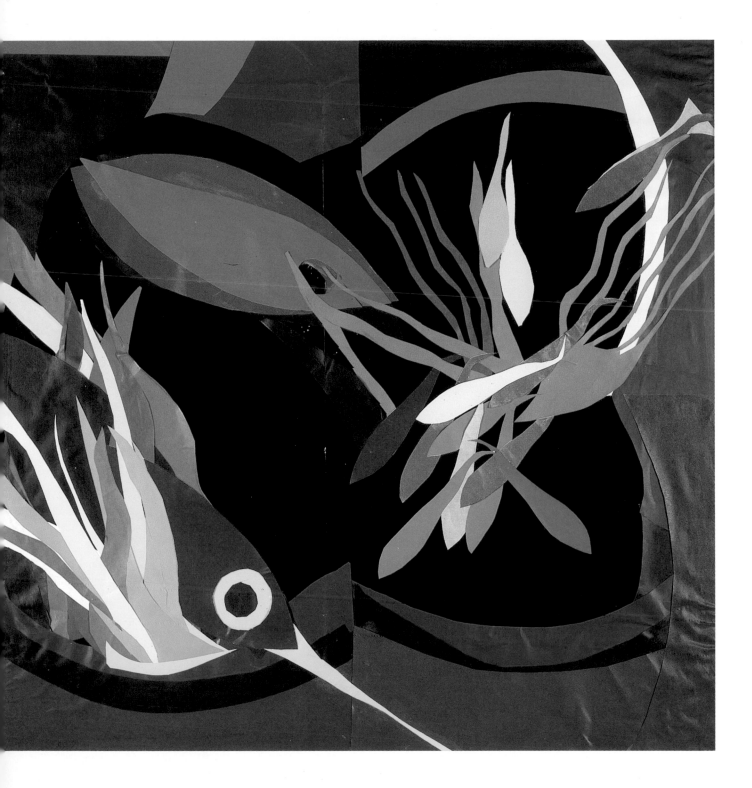

PHILODENDRON
UP A TREE

*P*hilodendron, a house plant in colder climes, grows to towering heights in Hawaii. Using large trees for support, its leaves become big as frisbees. A photograph of such a plant was transformed into a collage, emphasizing the natural rhythm of the leaves with their varied-colored veins as they move. Fadeless Papers in many colors were cut out in leaf forms, the shiny green paper added later to give sunlight to the leaves.

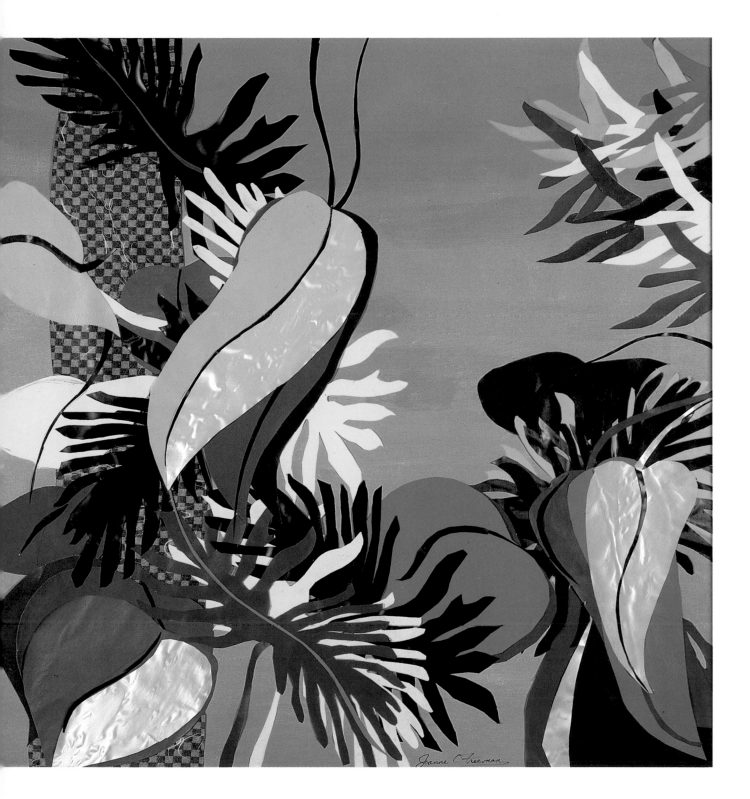

THE BLUE IS DOMINANT

An intricate intertwining of leaves produced this jungle-like collage. The blues, greens, magentas, and occasional oranges seemed to blend well with the light green acrylic surface. As I struggled with the composition, the cobalt blue was introduced as background and eventually as matting to pull the often competing colors together. The bright red leaf in the center is the finishing touch.

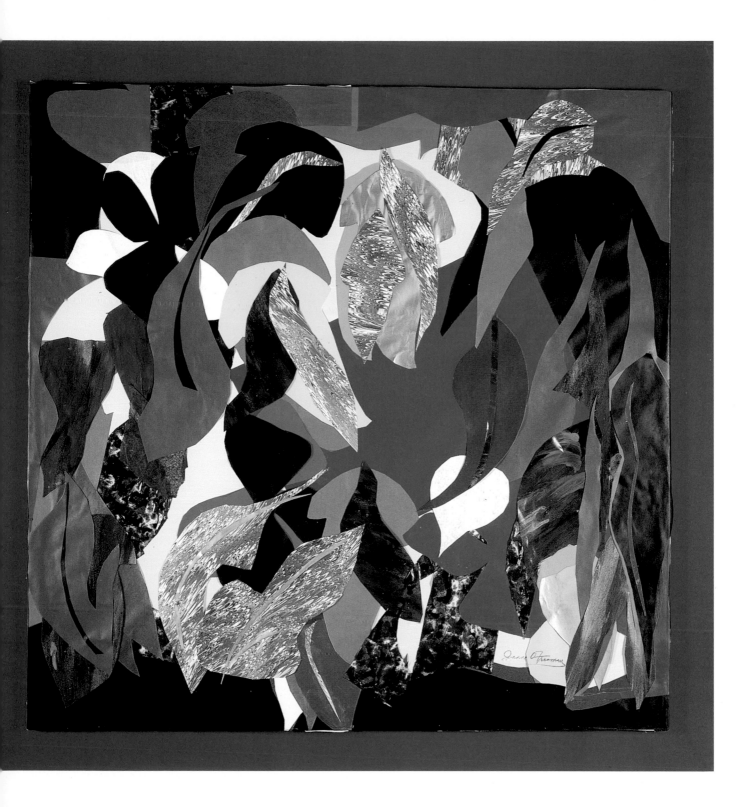

DREAMSCAPE FOR
DAVE AND SUZANNE

This is the only work I have done on assignment, with only the size and colors prescribed. With mint, lavender, and peach in mind, I picked out a roll of gift paper at an art store and began cutting out shapes reminiscent of growths in a fantasy garden. The pagoda suggested a foreign site, perhaps Shangri-La. The large bird breaking through the blue at the upper right is a good omen. Two canvases brought together by the frame became one piece.

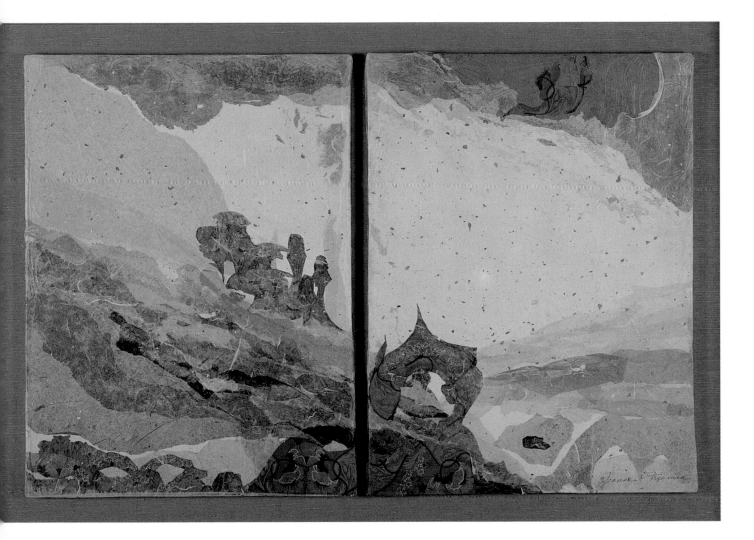

BENEATH THE SURFACE

*S*omething of the child lurks in this mix of seaweed, rocks, and hidden animal life. A snake entwined around a rock peers from behind a veil of tissue paper. An alligator floats into view on the right, and a unicorn-like creature appears out of place on the left. Magazine tear-outs were arranged as rocks, seaweed, and shells, and a few twigs and pieces of string sway in the underwater currents.

Trial-and-error was the process in this one. I began by covering the canvas with blue acrylic paint and as soon as it dried, glued down transparent tissue as the water line. Unhappy with what was appearing, I began picking off parts of the paper and found an interesting pattern stamped underneath. Next, I wet down some gauzy lace paper already glued down and rolled it back with my fingers to disclose a pleasing dimensional look.

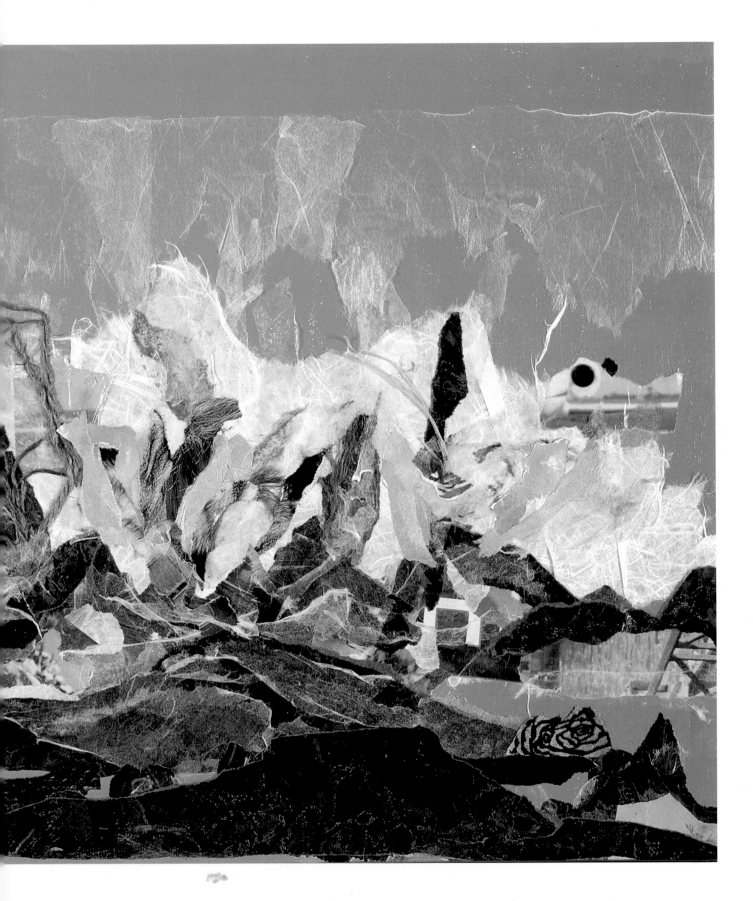

MARS AT NIGHT

Swirly, tortuous papers in red, blue, and black give this work an extra-terrestrial look, so I assumed this landscape must be from another planet. With pen and ink, I extended the brambly bushes tumbling down a ravine; magazine tear-outs formed the distant range with its glossy darkness. The sky is a striped blue tissue laid vertically, opening unexpectedly at the red gap on the right. A drop of red in the blue puddle near the bottom became my stamp of approval.

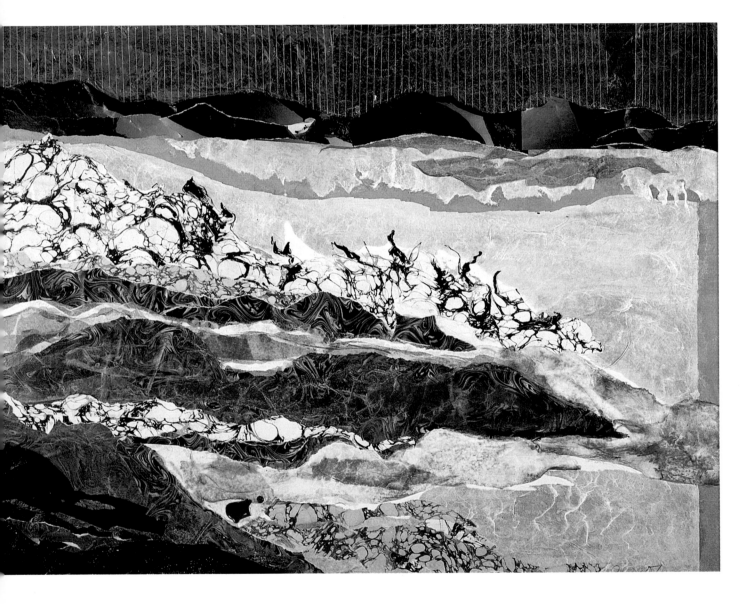

DISTANT CITIES

*W*hen a friend gave me some delicate stamped papers from Japan, I was immediately attracted to the challenge of working in colors I usually avoid. Instead of tearing the papers to make a specific form or design, as I normally do, I used them in their original square shapes. The background gave way to smaller squares and oblong pieces which turned into buildings, castles, pueblos, or plain sheds. They emerged as cities, villages and imaginary dwelling places. Apparently, the shapes spoke to an unconscious association between square forms and man made buildings.

MIDNIGHT TREE

"Midnight Tree" just worked. Done quickly and with abandon, it was made from cut outs from a fashion magazine and old recycled watercolors. It was too harsh, however, so I overlaid it with transparent black lace paper shot through with gold to change it into a mysterious twilight scene. The lace paper was fastened only at the edges, otherwise the glue would have dulled the fresh color of the tree.

FANTASY BIRDS

Another candidate for illustrative art, the colors purple, orange, white, and black were dramatic enough to cut into various shapes and sizes and place around the canvas until a composition took shape. But a big bird on the left came into view, and I added feathers and huge claws for the feet. The "schmoo-like" creature in the middle is totally happy after a full meal.

BEHIND THE 8-BALL

*T*his was a kind of "resting work." I had many pieces of paper left over and began gluing almost meditatively. When I added the picture of the girl behind the pool balls, the 8-ball flew to the moon.

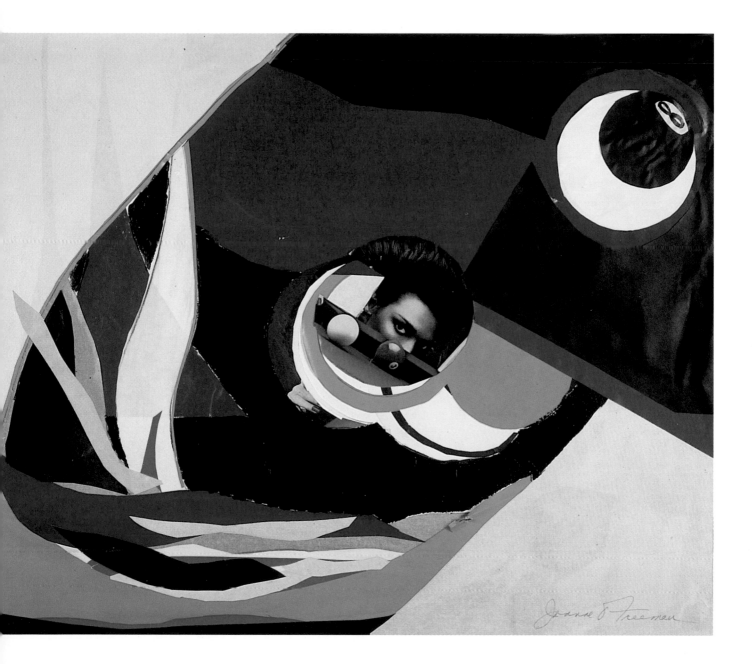

EVERYING CHANGES

This was my first collage. At first I was disappointed because I was trying to copy in paper the set-up planned by the teacher to get the students motivated. The set-up was a figured vase holding a bunch of roses with a round wicker tray as balance on the right. My roses became stems that seemed to be jumping from the head of the figure. The vase disappeared and the round dish became distorted. The words "Everything Changes" came on a whim.

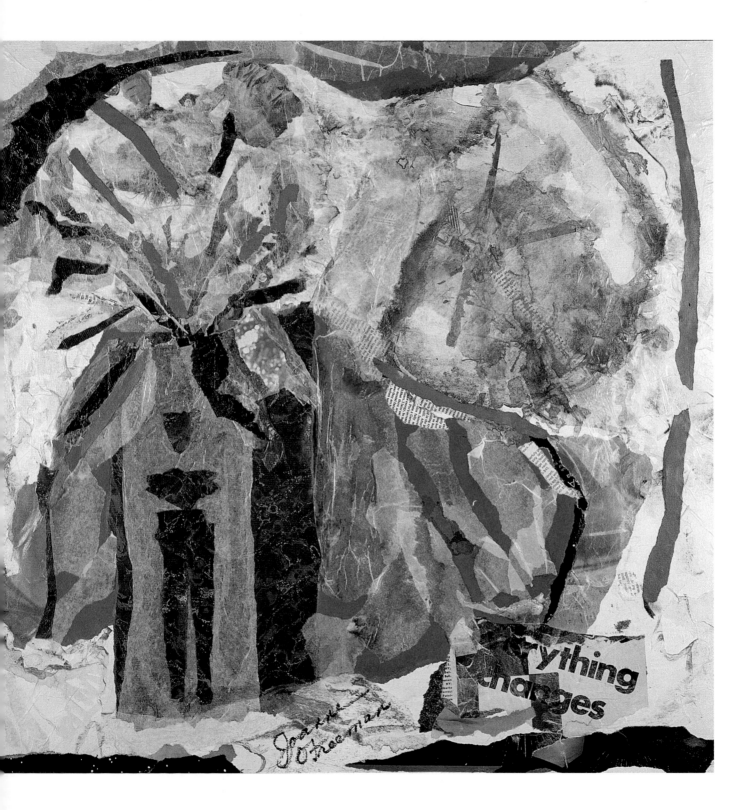

Joanne Freeman

rything changes

RETURN TO THE ORIENT

This is an early work, an experiment all the way. I was given some newspaper from the Orient and started gluing without a thought of what was to occur. Black and white newsprint called for some contrast in color, so I began laying down torn strips of red and pink tissue around the top edge. Irregular black tissue shapes added interest and new shades of color were added by multi-layering the tissues at the top. Still, the composition was incomplete until the Japanese woman jumped out at me from a magazine, and I put her in the middle of the collage where she belonged.

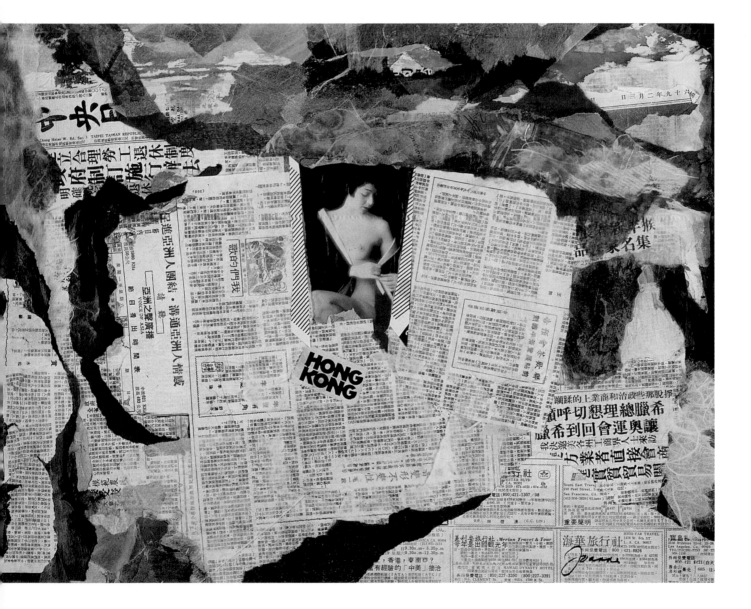

STEVE'S DREAM

*W*henever you start a new project there is always that blank canvas to face, so sometimes I use a photograph as inspiration and guide. The challenge is in translating what is in the photo into collage. "Steve's Dream" shows a surfer running with his board at sunset, hurrying past an irregularly-shaped farm fence, with cypress trees nearby. Early sundown changed the sky to apricot and made silhouettes of the fence and trees. The surfer's body is fashioned out of an ad for Obsession perfume (an unintentional but appropriate message), the fence from abstract gift paper, the cypress from punctured paper giving the impression of light shining through leaves.

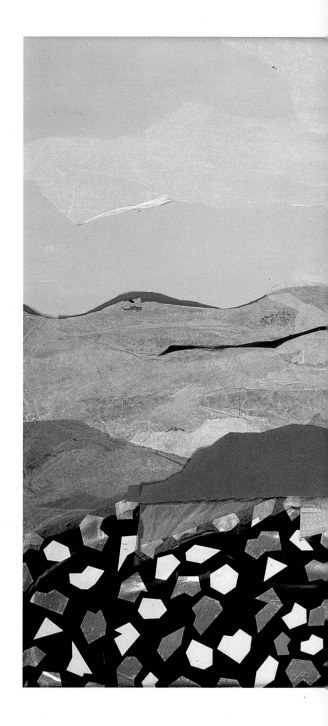

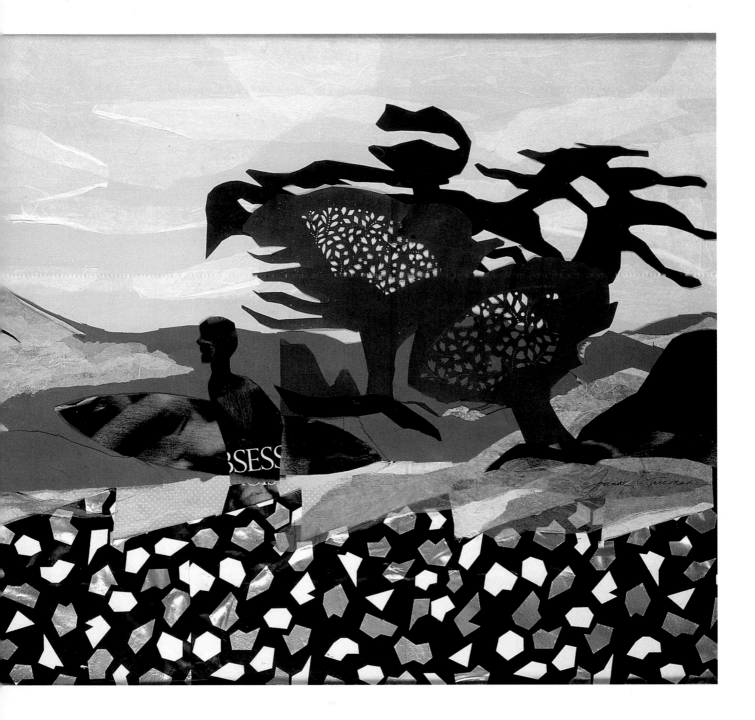

BLACK AND YELLOW
POLKA DOTS

*everal of my collages
have been inspired by printed paper bags from stores.
For this one, I tore out fashion pictures from old Vogue
magazines and combined them with dots and stripes
in various sizes, contrasting it all to a chrome yellow
background. This makes a colorful high-tech state-
ment. The faceless woman in the big hat commands
our attention, but look for other hidden presences.*

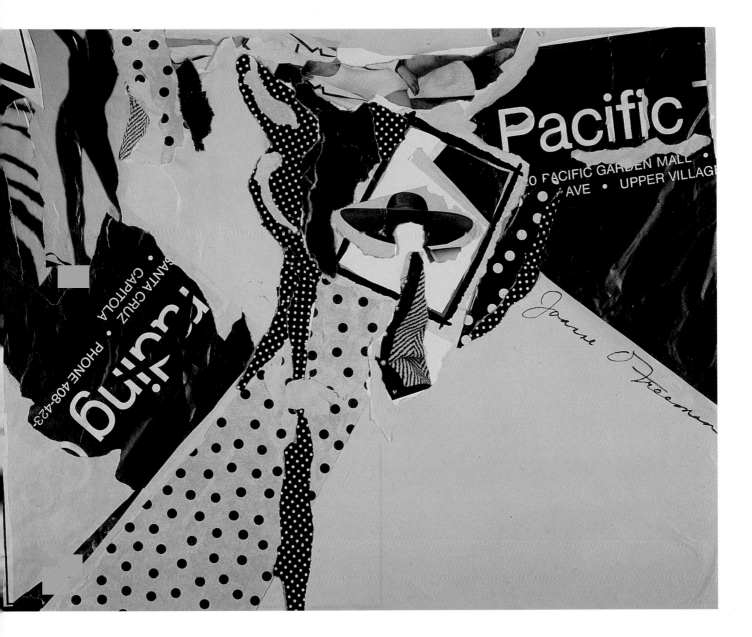

ROUGH TRADE

I began with a paper bag from a record shop called "Rough Trade," and tore out the insides of the letter and filled them with primary colors. The explosions of paper and zig-zags in bright green ripping through the canvas carries out the theme of youthful rebellion. This was a gift to my teenage son, a fan of punk rock.

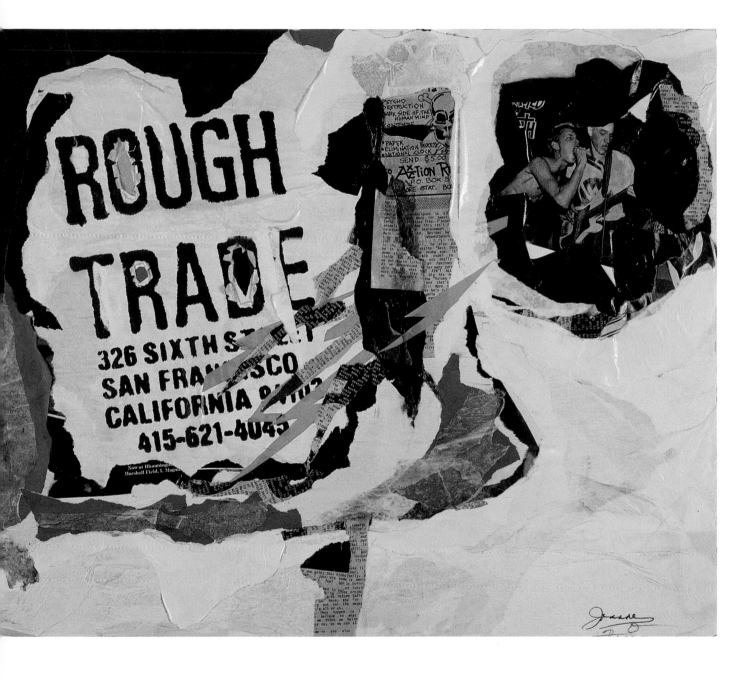

HER OTHER LIFE

In this early effort, I started with the fans, but soon the layering-over effect obscured them and more abstract shapes emerged. There are people here I saw only after I was done, making their appearance that much more intriguing. Two monk-like figures with long robes and hoods stand silently while a mysterious lady in pink awaits her turn.

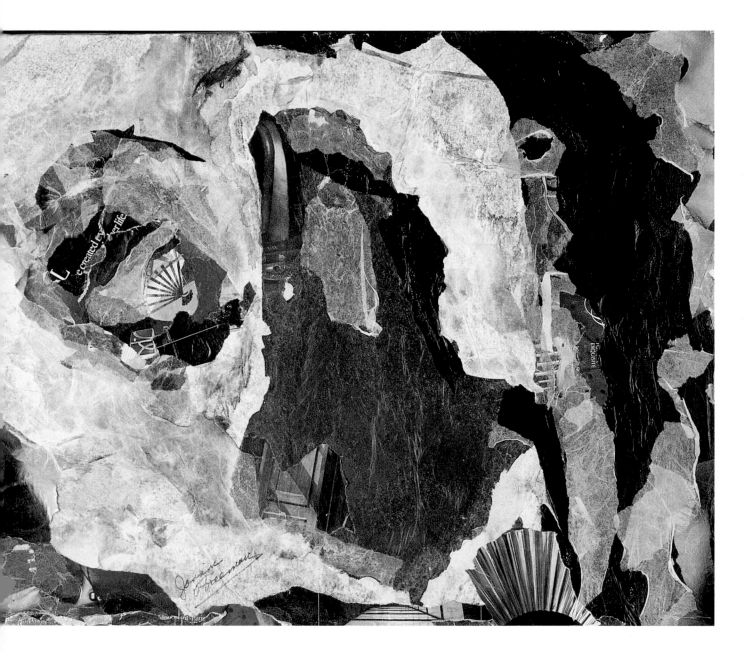

A WOMAN'S LOT

*T*his collage was almost worked to death. I first gathered a group of Mother's Day cards and moved them around the canvas. Frustration and anger led me to overlay and overlay until, in the finished work, only one small design of the original cards peeked through. Finally, figures began to emerge. A man in a business suit, distracted by work, is being ignored by a pregnant pale pink female turning away from him. She merges with a full purple breast facing her. A doll bride, lifeless but beautiful, represents childhood dreams, while a new-born baby at the bottom promises hope.

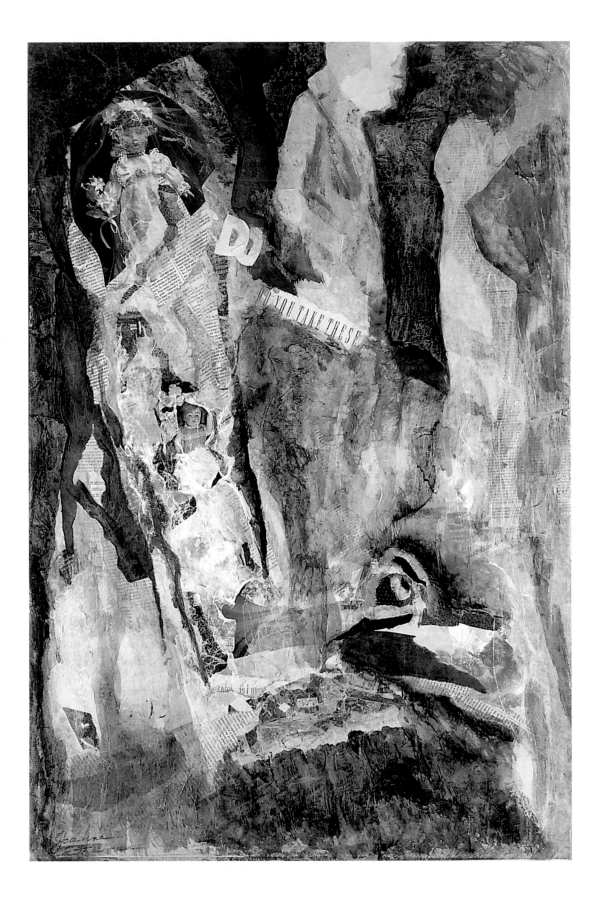

ANCIENT ROME IN RUINS

This is one of the collages that stayed abstract. I began with neutral colors— black, gold, off-white, and clay—and mixed them in a formal linear pattern. What ties this design together is the rhythm of the smaller stripes, diamond patterns, and black and white striped poles. The broken white statue head and distant black male figure on the left open a door to ancient Rome.

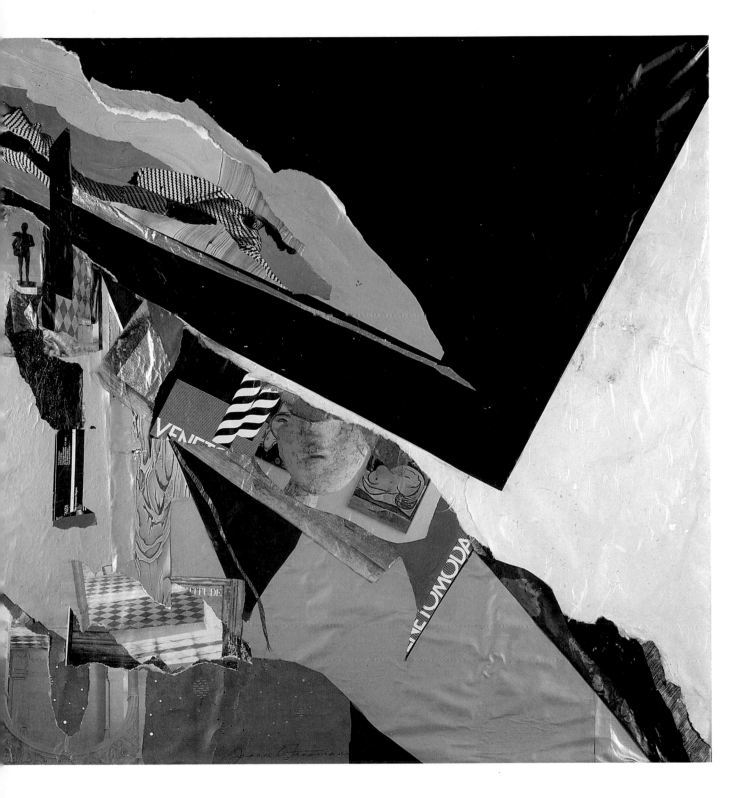

THE HARMONIC
CONVERGENCE

The day of the harmonic convergence, August 17, 1987, we hiked to an ancient Hawaiian heiau and were the only ones there. It's a holy place where long ago women danced the sacred hula, while priests threw lighted torches off the cliffs into the ocean below. The rocks are piled high and no one dares move them for fear of spirit intervention. Offerings made today or yesterday—drying hula skirts, bits of food, loving gifts—are tucked into the crevices of the rocky wall behind. We roamed the area for a half hour before more people arrived. The face peeking through the center of the collage is at one with the rocks, reeds, tree, and the wildness of Creation. Holiness exists everywhere.

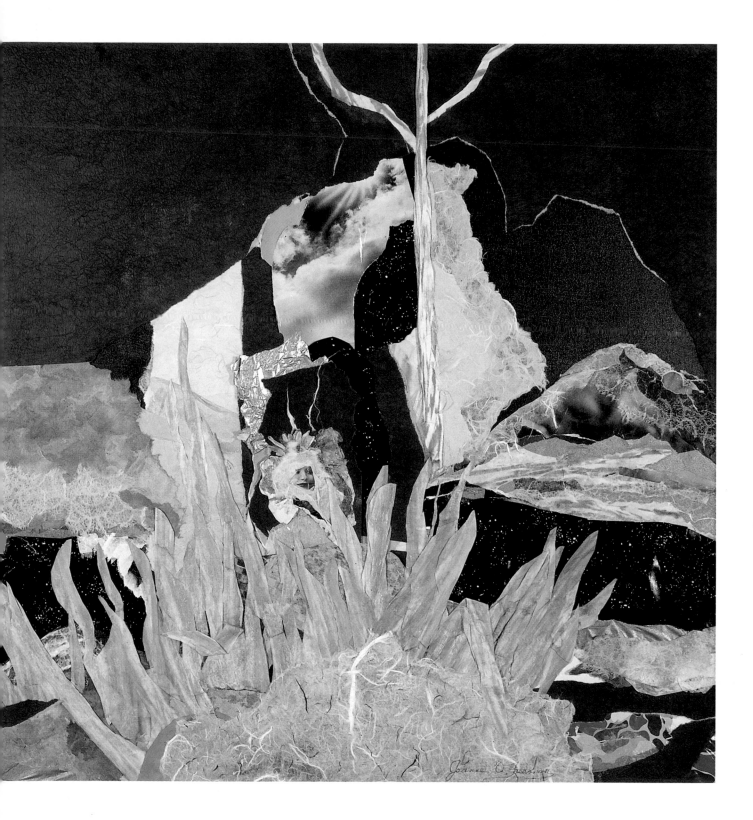